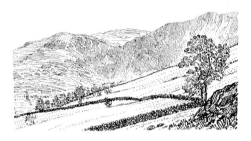

DIARY 2005

A Wainwright

FRANCES LINCOLN

Frances Lincoln Limited
4 Torriano Mews
Torriano Avenue
London NW5 2RZ
www.franceslincoln.com

The Wainwright Pocket Diary 2005
Copyright © Frances Lincoln 2004
Illustrations copyright © The Estate of A. Wainwright 1955, 1957, 1958, 1960,
1962, 1964 and 1966

Astronomical information reproduced, with permission, from data supplied by
HM Nautical Almanac Office, copyright © Council for the Central
Laboratory of the Research Councils

Printed and bound in Hong Kong

A CIP catalogue record is available for this book from the British Library.

ISBN 0 7112 2353 X

IMPORTANT NOTE

Pages from A. Wainwright's Pictorial Guides to the Lakeland Fells are used
in this diary **for illustration only**. Maps and instructions on ascents may
therefore not appear here in full. Walkers who wish to make any of the ascents
shown in this diary are strongly advised to consult the appropriate guide:

BLENCATHRA:
Book 5 The Northern Fells

BOWFELL:
Book 4 The Southern Fells

CATBELLS:
Book 6 The North Western Fells

CAUDALE MOOR:
Book 2 The Far Eastern Fells

GREAT GABLE:
Book 7 The Western Fells

HART SIDE:
Book 1 The Eastern Fells

KENTMERE PIKE:
Book 2 The Far Eastern Fells

MELLBREAK:
Book 7 The Western Fells

SCAFELL PIKE:
Book 4 The Southern Fells

TARN CRAG:
Book 3 The Central Fells

ULLOCK PIKE:
Book 5 The Northern Fells

WALLA CRAG
Book 3 The Central Fells

2005

January
```
M  T  W  T  F  S  S
            1  2
 3  4  5  6  7  8  9
10 11 12 13 14 15 16
17 18 19 20 21 22 23
24 25 26 27 28 29 30
31
```

February
```
M  T  W  T  F  S  S
       1  2  3  4  5  6
 7  8  9 10 11 12 13
14 15 16 17 18 19 20
21 22 23 24 25 26 27
28
```

March
```
M  T  W  T  F  S  S
       1  2  3  4  5  6
 7  8  9 10 11 12 13
14 15 16 17 18 19 20
21 22 23 24 25 26 27
28 29 30 31
```

April
```
M  T  W  T  F  S  S
             1  2  3
 4  5  6  7  8  9 10
11 12 13 14 15 16 17
18 19 20 21 22 23 24
25 26 27 28 29 30
```

May
```
M  T  W  T  F  S  S
                   1
 2  3  4  5  6  7  8
 9 10 11 12 13 14 15
16 17 18 19 20 21 22
23 24 25 26 27 28 29
30 31
```

June
```
M  T  W  T  F  S  S
    1  2  3  4  5
 6  7  8  9 10 11 12
13 14 15 16 17 18 19
20 21 22 23 24 25 26
27 28 29 30
```

July
```
M  T  W  T  F  S  S
             1  2  3
 4  5  6  7  8  9 10
11 12 13 14 15 16 17
18 19 20 21 22 23 24
25 26 27 28 29 30 31
```

August
```
M  T  W  T  F  S  S
 1  2  3  4  5  6  7
 8  9 10 11 12 13 14
15 16 17 18 19 20 21
22 23 24 25 26 27 28
29 30 31
```

September
```
M  T  W  T  F  S  S
          1  2  3  4
 5  6  7  8  9 10 11
12 13 14 15 16 17 18
19 20 21 22 23 24 25
26 27 28 29 30
```

October
```
M  T  W  T  F  S  S
                1  2
 3  4  5  6  7  8  9
10 11 12 13 14 15 16
17 18 19 20 21 22 23
24 25 26 27 28 29 30
31
```

November
```
M  T  W  T  F  S  S
    1  2  3  4  5  6
 7  8  9 10 11 12 13
14 15 16 17 18 19 20
21 22 23 24 25 26 27
28 29 30
```

December
```
M  T  W  T  F  S  S
          1  2  3  4
 5  6  7  8  9 10 11
12 13 14 15 16 17 18
19 20 21 22 23 24 25
26 27 28 29 30 31
```

2006

January
```
M  T  W  T  F  S  S
                   1
 2  3  4  5  6  7  8
 9 10 11 12 13 14 15
16 17 18 19 20 21 22
23 24 25 26 27 28 29
30 31
```

February
```
M  T  W  T  F  S  S
       1  2  3  4  5
 6  7  8  9 10 11 12
13 14 15 16 17 18 19
20 21 22 23 24 25 26
27 28
```

March
```
M  T  W  T  F  S  S
       1  2  3  4  5
 6  7  8  9 10 11 12
13 14 15 16 17 18 19
20 21 22 23 24 25 26
27 28 29 30 31
```

April
```
M  T  W  T  F  S  S
                1  2
 3  4  5  6  7  8  9
10 11 12 13 14 15 16
17 18 19 20 21 22 23
24 25 26 27 28 29 30
```

May
```
M  T  W  T  F  S  S
 1  2  3  4  5  6  7
 8  9 10 11 12 13 14
15 16 17 18 19 20 21
22 23 24 25 26 27 28
29 30 31
```

June
```
M  T  W  T  F  S  S
          1  2  3  4
 5  6  7  8  9 10 11
12 13 14 15 16 17 18
19 20 21 22 23 24 25
26 27 28 29 30
```

July
```
M  T  W  T  F  S  S
                1  2
 3  4  5  6  7  8  9
10 11 12 13 14 15 16
17 18 19 20 21 22 23
24 25 26 27 28 29 30
31
```

August
```
M  T  W  T  F  S  S
    1  2  3  4  5  6
 7  8  9 10 11 12 13
14 15 16 17 18 19 20
21 22 23 24 25 26 27
28 29 30 31
```

September
```
M  T  W  T  F  S  S
             1  2  3
 4  5  6  7  8  9 10
11 12 13 14 15 16 17
18 19 20 21 22 23 24
25 26 27 28 29 30
```

October
```
M  T  W  T  F  S  S
                   1
 2  3  4  5  6  7  8
 9 10 11 12 13 14 15
16 17 18 19 20 21 22
23 24 25 26 27 28 29
30 31
```

November
```
M  T  W  T  F  S  S
       1  2  3  4  5
 6  7  8  9 10 11 12
13 14 15 16 17 18 19
20 21 22 23 24 25 26
27 28 29 30
```

December
```
M  T  W  T  F  S  S
             1  2  3
 4  5  6  7  8  9 10
11 12 13 14 15 16 17
18 19 20 21 22 23 24
25 26 27 28 29 30 31
```

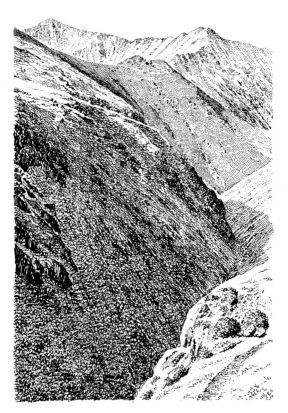

Scaley Beck

ALFRED WAINWRIGHT AND THE PICTORIAL GUIDES TO THE LAKELAND FELLS

All the pages used to illustrate this pocket diary come from the legendary Pictorial Guides to the Lakeland Fells by A. Wainwright – author, artist and fellwanderer. Originally compiled in the 1950s and early 1960s, Wainwright's Pictorial Guides are surely the most distinctive and unusual walking guides ever. They contain vivid descriptions of the fells he loved, intricate pen-and-ink sketches, detailed maps of ascents and ridge walks and, of course, pithy words of advice for walkers who follow in his footsteps.

Born in Blackburn in 1907, Wainwright left school at the age of thirteen to work as an office boy in the Borough Engineer's office. Years of evening classes followed while he earned his professional qualifications as an accountant. A holiday to the Lake District at the age of twenty-three changed his life by kindling a lifelong passion for the fells. In 1941 he was offered a post in Kendal, where he subsequently rose to become a popular Borough Treasurer. From then on he devoted every spare minute of his days to researching and compiling the original seven Pictorial Guides. After the last of these appeared in 1966, further Pictorial Guides followed, along with twenty-nine books of sketches of different regions of England, Scotland and Wales. In 1974 he became Chairman of Animal Rescue, Cumbria, and thanks to the book royalties he contributed to the charity, a permanent animal shelter was established near Kendal.

A. Wainwright died in 1991 at the age of eighty-four.

OPPOSITE: view of Blencathra

Walla Crag

1234'

'Wallow Crag'
on old editions
of Ordnance
Survey maps

Some walkers have
difficulty in
remembering
the altitudes
of the fells.
There is no
excuse here
for anybody
who can
count up
to four.

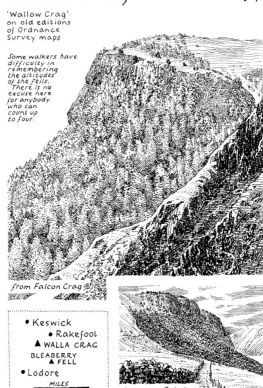

from Falcon Crag

• Keswick
 • Rakefoot
 ▲ WALLA CRAG
 BLEABERRY
 ▲ FELL
• Lodore

MILES
0 1 2 3

from near Rakefoot

DECEMBER ~ JANUARY

MONDAY 27

Holiday, UK

TUESDAY 28

Holiday, UK

WEDNESDAY 29

THURSDAY 30

FRIDAY 31

New Year's Eve

SATURDAY 1

New Year's Day

SUNDAY 2

JANUARY

3 MONDAY

Last Quarter

Holiday, UK

4 TUESDAY

Holiday, Scotland

5 WEDNESDAY

6 THURSDAY

Epiphany

7 FRIDAY

8 SATURDAY

9 SUNDAY

NATURAL FEATURES

The pleasant Vale of Keswick, surely one of earth's sweetest landscapes, is surrounded by mountains of noble proportions with an inner circle of lesser fells which deserve more than the name of foothills, each having strong individual characteristics, a definite and distinctive appearance, and a natural beauty all its own. Among these is Walla Crag, an eminence of intermingled rocks and trees overlooking the east shore of lovely Derwentwater: of moderate elevation yet steep, romantic, challenging. Seen from the lake the hoary top seems unattainable, yet it may be gained by the gentlest of ascents for the slopes beyond the upper fringe of crag descend easily, accompanied by Brockle Beck, almost to the streets of Keswick.

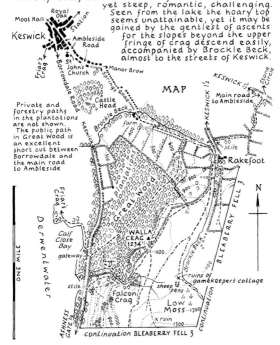

Private and forestry paths in the plantations are not shown. The public path in Great Wood is an excellent short cut between Borrowdale and the main road to Ambleside

ASCENT FROM KESWICK
1000 feet of ascent : 2½ miles

On a first visit it is easy to go astray here. The good cart-track from Rakefoot continues (soon deteriorating) in the direction of Bleaberry Fell: the less distinct branch path to Walla Crag follows the wall round to the right. Parties have been found toiling up Bleaberry Fell under the impression that they were climbing Walla Crag, an excusable mistake, for the former comes clearly into view ahead from the cart-track while the latter is out of sight, and, in any case, is not conspicuous from this side. A signpost would be useful at this point.

Note that an exciting (but unofficial) path passes through this gap in the wall and skirts the edge of the escarpment on its way to the summit, providing excellent views en route.

The iron grid in the cart-track was installed by the Army to facilitate the passage of tanks during the war when the fell was a training ground.

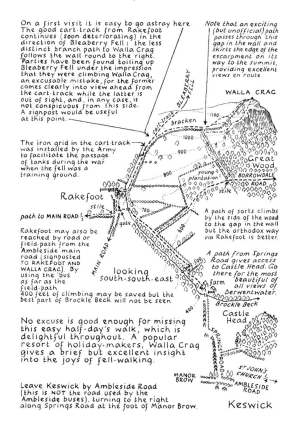

path to MAIN ROAD ½

Rakefoot may also be reached by road or field-path from the Ambleside main road (signposted TO RAKEFOOT and WALLA CRAG). By using the 'bus as far as the field-path 400 feet of climbing may be saved but the best part of Brockle Beck will not be seen.

A path of sorts climbs by the side of the wood to the gap in the wall but the orthodox way via Rakefoot is better.

A path from Springs Road gives access to Castle Head. Go there for the most beautiful of all views of Derwentwater.

No excuse is good enough for missing this easy half-day's walk, which is delightful throughout. A popular resort of holiday-makers, Walla Crag gives a brief but excellent insight into the joys of fell-walking.

looking south-south-east

Leave Keswick by Ambleside Road (this is NOT the road used by the Ambleside buses), turning to the right along Springs Road at the foot of Manor Brow.

Keswick

JANUARY

New Moon

MONDAY **10**

TUESDAY **11**

WEDNESDAY **12**

THURSDAY **13**

FRIDAY **14**

SATURDAY **15**

SUNDAY **16**

JANUARY

17 MONDAY

18 TUESDAY

19 WEDNESDAY

20 THURSDAY

21 FRIDAY

22 SATURDAY

23 SUNDAY

ASCENT FROM THE BORROWDALE ROAD
950 feet of ascent : 1 mile (2½ from Keswick)

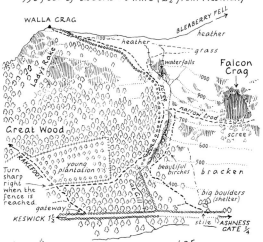

WALLA CRAG

BLEABERRY FELL

heather

heather

grass

waterfalls

Falcon Crag

Lady's Rake

1000

900

narrow trod

700

scree

Great Wood

600

500

bracken

young plantation

beautiful birches

400

big boulders (shelter)

Turn sharp right when the fence is reached

RAKEFOOT

gateway

KESWICK 1½

stile

ASHNESS GATE ¾

Derwentwater

looking east

Waterfalls in Cat Gill

Alternative starts are given. The 'purest' route is that from the gateway, which keeps throughout to the Walla Crag side of Cat Gill, but trees shut out views that are too good to be missed. This defect is remedied by starting from the stile 150 yards beyond the point where the road crosses Cat Gill, a route with excellent views but calling for a little care higher up, just before joining the other path on the north bank of the gill. (A narrow trod here, on the south bank, leads excitingly to the base of Falcon Crag, which is worth seeing at close quarters, especially so from the small rise beyond.)

A beautiful short climb up steep colourful slopes overlooking Derwentwater. If the starting point on the road is reached via Friar's Crag and Calf Close Bay, and if the return is made via Rakefoot and Brockle Beck, this becomes the best walk easily attainable in a half-day from Keswick.

THE SUMMIT

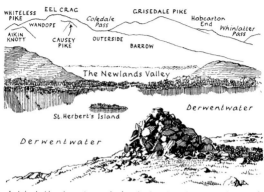

A delectable place for a picnic, the heathery top of Walla Crag is also a favourite viewpoint for Derwentwater, seen directly below the long steep escarpment. A profusion of decayed tree-stumps indicates that the summit, now bare, was at one time thickly wooded; many trees survive nearby, all west of the wall crossing the top of the fell, as is the cairn, 60 yards distant.

DESCENTS: Keep to the paths: the dangers of straying from them should be obvious. An inviting opening in the cliff (Lady's Rake) 150 yards south of the cairn is a trap to be avoided. In mist, note that the wall links Rakefoot and the Borrowdale road, and that the paths follow it. The descent to Rakefoot is easy; the other route is rough but more interesting.

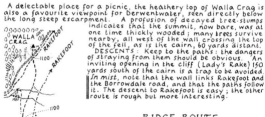

RIDGE ROUTE

TO BLEABERRY FELL, 1932'
1¼ miles : S, then SSE curving SE
Depression at 1070'
900 feet of ascent
A dull climb relieved by fine views

Start along the Ashness Bridge path, crossing to a higher track when a stream is reached and then aiming for the left side of the prominent mound. Detour right to join the first cairn.

JANUARY

MONDAY **24**

Full Moon

TUESDAY **25**

WEDNESDAY **26**

THURSDAY **27**

FRIDAY **28**

SATURDAY **29**

SUNDAY **30**

Bowfell

2960'

'Bow Fell' (two words)
on Ordnance Survey maps

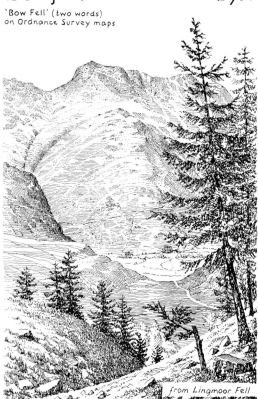

from Lingmoor Fell

JANUARY ~ FEBRUARY

MONDAY **31**

TUESDAY **1**

Last Quarter

WEDNESDAY **2**

THURSDAY **3**

FRIDAY **4**

SATURDAY **5**

SUNDAY **6**

FEBRUARY

7 **MONDAY**

8 **TUESDAY**

New Moon

Shrove Tuesday

9 **WEDNESDAY**

Ash Wednesday
Chinese New Year

10 **THURSDAY**

Islamic New Year (subject to sighting of the moon)

11 **FRIDAY**

12 **SATURDAY**

13 **SUNDAY**

ASCENT FROM ESKDALE
2900 feet of ascent : 7½ miles from Boot
BOWFELL

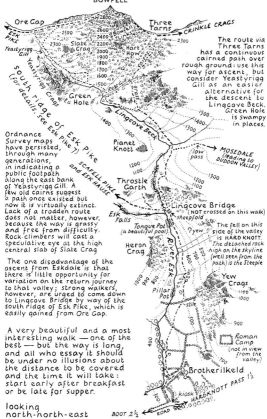

The route via Three Tarns has a continuous cairned path over rough ground: use this way for ascent, but consider Yeastyrigg Gill as an easier alternative for the descent to Lingcove Beck. Green Hole is swampy in places.

Ordnance Survey maps have persisted, through many generations, in indicating a public footpath along the east bank of Yeastyrigg Gill. A few old cairns suggest a path once existed but now it is virtually extinct. Lack of a trodden route does not matter, however, because the way is grassy and free from difficulty. Rock climbers will cast a speculative eye at the high central slab of Slate Crag.

The one disadvantage of the ascent from Eskdale is that there is little opportunity for variation on the return journey to that valley; strong walkers, however, are urged to come down to Lingcove Bridge by way of the south ridge of Esk Pike, which is easily gained from Ore Gap.

A very beautiful and a most interesting walk — one of the best — but the way is long, and all who essay it should be under no illusions about the distance to be covered and the time it will take: start early after breakfast or be late for supper.

looking
north-north-east

THE VIEW

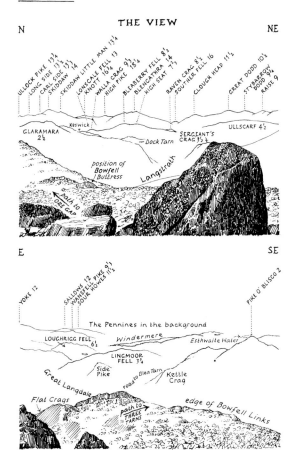

N

ULLOCK PIKE 13¾
LONG SIDE 13¼
CARL SIDE 13½
SKIDDAW 13½
SKIDDAW LITTLE MAN 13¾
LONSCALE FELL 13
KNOTT 16¼
WALLA CRAG 9½
HIGH PIKE 18¼
BLEABERRY FELL 8½
BLENCATHRA 14
HIGH SEAT 7½
RAVEN CRAG 8½
SOUTHER FELL 16
CLOUGH HEAD 11½
GREAT DODD 10½
STYBARROW DODD 9¼
RAISE 9

NE

Keswick

GLARAMARA
2½

— Dock Tarn

SERGEANT'S
CRAG 3½

ULLSCARF 4½

position of
Bowfell
Buttress

Langstrath

Path to
OXE GAP

E

YOKE 12

SALLOWS 12
WANSFELL PIKE 9½
SOUR HOWES 11½

The Pennines in the background

PIKE O' BLISCO 2

SE

LOUGHRIGG FELL
6½

Windermere

Esthwaite Water

LINGMOOR
FELL 3¾

Great Langdale

Side
Pike

road to Blea Tarn

Kettle
Crag

Flat Crags

path to
THREE
TARNS

edge of Bowfell Links

FEBRUARY

MONDAY **14**

St Valentine's Day

TUESDAY **15**

First Quarter

WEDNESDAY **16**

THURSDAY **17**

FRIDAY **18**

SATURDAY **19**

SUNDAY **20**

FEBRUARY

21 MONDAY

22 TUESDAY

23 WEDNESDAY

24 THURSDAY Full Moon

25 FRIDAY

26 SATURDAY

27 SUNDAY

THE VIEW

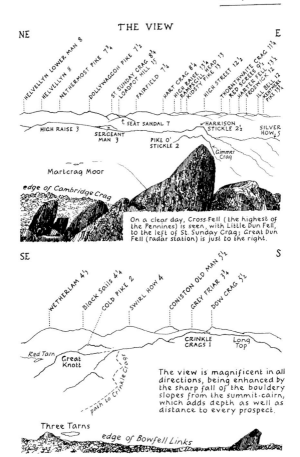

NE · · · E

HELVELLYN LOWER MAN 8
HELVELLYN 8
NETHERMOST PIKE 7¾
DOLLYWAGGON PIKE 7½
ST SUNDAY CRAG 8¼
LOADPOT HILL 15
FAIRFIELD 7¾
HART CRAG 8¼
HIGH RAISE 13½
KIRKSTONE PIKE 13
KIDSTY PIKE 13
HIGH STREET 12½
THORNTHWAITE CRAG 11¼
RED SCREES 9½
HARTER FELL 13½
FROSWICK 12
ILL BELL 12
KENTMERE PIKE 13¾

HIGH RAISE 3
SERGEANT MAN 3
SEAT SANDAL 7
PIKE O' STICKLE 2
HARRISON STICKLE 2½
Gimmer Crag
SILVER HOW 5

Martcrag Moor

edge of Cambridge Crag

On a clear day, Cross-Fell (the highest of the Pennines) is seen, with Little Dun Fell, to the left of St. Sunday Crag; Great Dun Fell (radar station) is just to the right.

SE · · · S

WETHERLAM 4½
BLACK SAILS 4¼
COLD PIKE 2
SWIRL HOW 4
CONISTON OLD MAN 5½
GREY FRIAR 3¾
DOW CRAG 5½

Red Tarn
Great Knott
path to Crinkle Crags
CRINKLE CRAGS 1
Long Top

The view is magnificent in all directions, being enhanced by the sharp fall of the bouldery slopes from the summit-cairn, which adds depth as well as distance to every prospect.

Three Tarns
edge of Bowfell Links

Tarn Crag

1801'

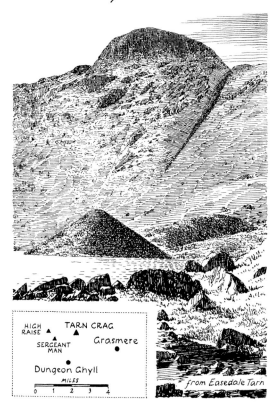

HIGH RAISE ▲ TARN CRAG ▲

SERGEANT MAN ▲

Grasmere ●

Dungeon Ghyll ●

MILES
0 1 2 3 4

from Easedale Tarn

FEBRUARY ~ MARCH

MONDAY 28

TUESDAY 1

St David's Day

WEDNESDAY 2

Last Quarter

THURSDAY 3

FRIDAY 4

SATURDAY 5

SUNDAY 6

Mothering Sunday, UK

MARCH

7 MONDAY

8 TUESDAY

9 WEDNESDAY

10 THURSDAY New Moon

11 FRIDAY

12 SATURDAY

13 SUNDAY

NATURAL FEATURES

Ever since it first became fashionable to make excursions to behold the scenic wonders of the English Lake District Easedale Tarn has been a popular venue for visitors: a romantic setting, inurned in bracken-clad moraines with a background of craggy fells, and easy accessibility from Grasmere, have combined to make this a favourite place of resort. The dominant feature in the rugged skyline around the head of the tarn is the arching curve of Tarn Crag, above a wild rocky slope that plunges very steeply to the dark waters at its base. But rough though this slope is, it at least has the benefit of sunlight to colour and illuminate the grimness, whereas the opposite flanks, facing north into Far Easedale, form a scene of unrelieved gloom, with the black forbidding precipices of Deer Bields and Fern Gill seeming to cast a permanent shadow across the valley: one vertical and fissured crag here has quite a reputation amongst rock-climbers.

Easedale Tarn is not the only jewel in Tarn Crag's lap. A smaller sheet of water, Codale Tarn, occupies a hollow on a higher shelf; beyond, indefinite slopes climb to the top of the parent fell, High Raise.

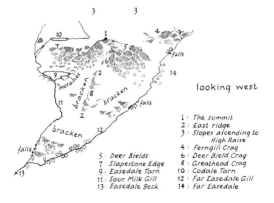

looking west

1 : The summit
2 : East ridge
3 : Slopes ascending to
 High Raise
4 : Ferngill Crag
5 : Deer Bields
6 : Deer Bield Crag
7 : Slapestone Edge
8 : Greathead Crag
9 : Easedale Tarn
10 : Codale Tarn
11 : Sour Milk Gill
12 : Far Easedale Gill
13 : Easedale Beck
14 : Far Easedale

ASCENT FROM GRASMERE
via SOUR MILK GILL
1600 feet of ascent : 3 miles

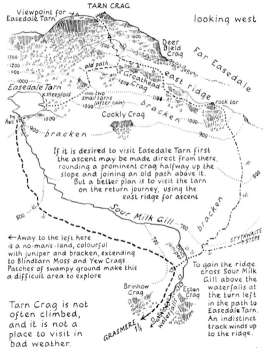

TARN CRAG

Viewpoint for
Easedale Tarn

looking west

Deer
Bield
Crag

Far Easedale

old path

east ridge

Greathead
Crag

Easedale Tarn

sheepfold

two
small tarns
(after rain)

rock tor

Cockly Crag

bracken

hut

bracken

bracken

If it is desired to visit Easedale Tarn first
the ascent may be made direct from there,
rounding a prominent crag halfway up the
slope and joining an old path above it.
But a better plan is to visit the tarn
on the return journey, using the
east ridge for ascent

Sour Milk Gill

STYTHWAITE
STEPS

←Away to the left here
is a no-man's-land, colourful
with juniper and bracken, extending
to Blindtarn Moss and Yew Crags.
Patches of swampy ground make this
a difficult area to explore

juniper

To gain the ridge
cross Sour Milk
Gill above the
waterfalls at
the turn left
in the path to
Easedale Tarn.
An indistinct
track winds up
to the ridge.

Brinhow
Crag

Ecton
Crag

Tarn Crag is not
often climbed,
and it is not a
place to visit in
bad weather.

waterfall

GRASMERE 1¼

It is not blessed with paths, but an intermittent track
follows the natural line of ascent, the east ridge. As
the summit is approached it assumes a formidable
appearance but is easily reached by a grassy rake.

MARCH

MONDAY **14**

TUESDAY **15**

WEDNESDAY **16**

First Quarter

THURSDAY **17**

St Patrick's Day – Holiday, Northern Ireland

FRIDAY **18**

SATURDAY **19**

SUNDAY **20**

Palm Sunday
Vernal Equinox

MARCH

21 MONDAY

22 TUESDAY

23 WEDNESDAY

24 THURSDAY

Maundy Thursday

25 FRIDAY

Full Moon

Good Friday
Holiday, UK

26 SATURDAY

27 SUNDAY

Easter Day
British Summertime begins

THE VIEW

Principal Fells

The outstanding feature is a splendid prospect of Easedale running down into the vale of Grasmere a picture of great charm enhanced by the steep declivity in the foreground. The Helvellyn range is well seen, but there is little worthy of note in other directions.

Easedale Tarn cannot be seen from the main cairn although the hut there is in sight. Cross the grassy hollow to a big cairn 200 yards south and walk a few paces beyond for a striking bird's-eye view of the tarn.

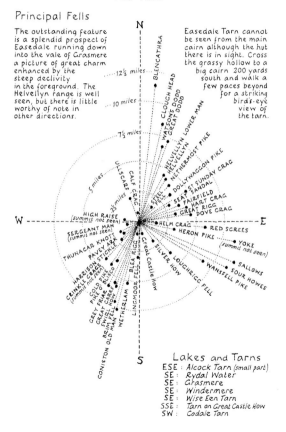

Lakes and Tarns

ESE : Alcock Tarn (small part)
SE : Rydal Water
SE : Grasmere
SE : Windermere
SE : Wise Een Tarn
SSE : Tarn on Great Castle How
SW : Codale Tarn

2397'

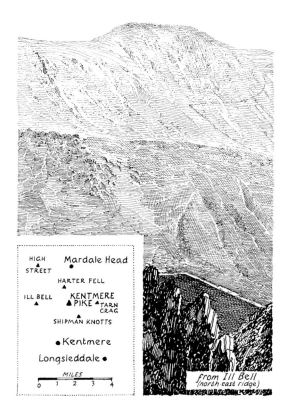

HIGH
STREET ▲

Mardale Head ●

HARTER FELL ▲

ILL BELL ▲

KENTMERE
▲ PIKE ▲ TARN
CRAG
▲

SHIPMAN KNOTTS ▲

● Kentmere

Longsleddale ●

MILES

0 1 2 3 4

from Ill Bell
(north east ridge)

MARCH ~ APRIL

MONDAY **28**

Easter Monday
Holiday, UK (exc. Scotland)

TUESDAY **29**

WEDNESDAY **30**

THURSDAY **31**

FRIDAY **1**

Last Quarter

SATURDAY **2**

SUNDAY **3**

APRIL

4 MONDAY

5 TUESDAY

6 WEDNESDAY

7 THURSDAY

8 FRIDAY New Moon

9 SATURDAY

10 SUNDAY

NATURAL FEATURES

A high ridge, a counterpart to the Ill Bell range across Kentmere, rises steeply to enclose the upper part of that valley on the east. This is the south ridge of Harter Fell, which, soon after leaving the parent summit, swells into the bare, rounded top of Kentmere Pike, a fell of some importance and of more significance to the inhabitants of the valley, as its name suggests, than Harter Fell itself. The Kentmere slope, wooded at its foot and craggy above, is of little interest, but the eastern flank is altogether of sterner stuff, falling precipitously into the narrow jaws of Longsleddale: a most impressive scene. Here, abrupt cliffs riven by deep gullies tower high above the crystal waters of the winding Sprint and give to the dalehead a savageness that contrasts strikingly with the placid sweetness of the Sadgill pastures just out of their shadow.

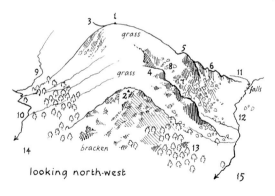

looking north-west

1 : *The summit*	2 : *Shipman Knotts*
3 : *Ridge continuing to Harter Fell*	
4 : *Goat Scar*	5 : *Steel Pike*
6 : *Steel Rigg*	7 : *Raven Crag*
8 : *Settle Earth*	9 : *Ullstone Gill*
10 : *River Kent*	11 : *Wren Gill*
12 : *River Sprint*	13 : *Sadgill Woods*
14 : *Kentmere*	15 : *Longsleddale*

ASCENT FROM KENTMERE
1900 feet of ascent : 3 miles

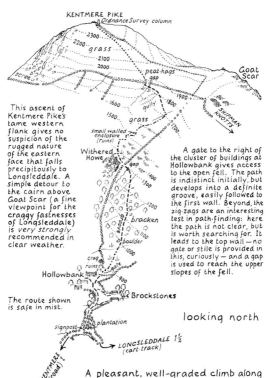

KENTMERE PIKE
Ordnance Survey column

2300
grass
2200
2100
2000
scree
peat-hags gap
1600
gully
1900
1800
Goat Scar
1500
grass
1700
SHIPMAN KNOTTS
small walled enclosure (ruins)
Withered Howe
gap
1400
1300
1200
bracken
1100
boulder
1000
crag
ruins
Hollowbank
900
Brockstones
signpost
plantation
looking north
LONGSLEDDALE 1½
(cart-track)
KENTMERE (road)

This ascent of Kentmere Pike's tame western flank gives no suspicion of the rugged nature of the eastern face that falls precipitously to Longsleddale. A simple detour to the cairn above Goat Scar (a fine viewpoint for the craggy fastnesses of Longsleddale) is very strongly recommended in clear weather.

A gate to the right of the cluster of buildings at Hollowbank gives access to the open fell. The path is indistinct initially, but develops into a definite groove, easily followed to the first wall. Beyond, the zig-zags are an interesting test in path-finding: here the path is not clear, but is worth searching for. It leads to the top wall — no gate or stile is provided in this, curiously — and a gap is used to reach the upper slopes of the fell.

The route shown is safe in mist.

A pleasant, well-graded climb along an old grooved path, with excellent views of Kentmere, although the last mile is dull. This is the easiest way onto the Harter Fell ridge.

APRIL

MONDAY **11**

TUESDAY **12**

WEDNESDAY **13**

THURSDAY **14**

FRIDAY **15**

First Quarter

SATURDAY **16**

SUNDAY **17**

APRIL

18 MONDAY

19 TUESDAY

20 WEDNESDAY

21 THURSDAY

Birthday of Queen Elizabeth II

22 FRIDAY

23 SATURDAY

St George's Day

24 SUNDAY

Full Moon

Passover (Pesach), First Day

THE VIEW

The distant view of Lakeland is interrupted by the nearer heights across Kentmere; it is interesting to note that the summit-cone of Ill Bell exactly conceals Scafell Pike. More satisfactory prospects are south-east, towards the Pennines, and south-west, over Windermere to Morecambe Bay.

Principal Fells

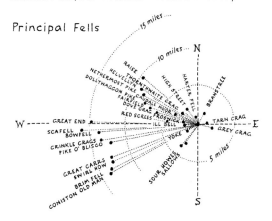

Lakes and Tarns
SSW : Windermere
Kentmere Reservoir is brought into view by walking 50 yards in the direction of Ill Bell.

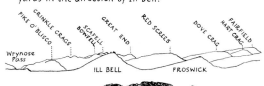

Catbells

1481'

Cat Bells
(two words)
on Ordnance maps

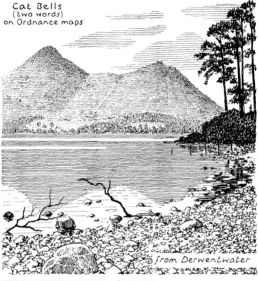

from Derwentwater

- Portinscale
 - Keswick
- Stair
 ▲ CATBELLS
- Little Town
 ▲ MAIDEN MOOR
 - Grange

MILES
0 1 2 3 4

from the Portinscale path

APRIL ~ MAY

MONDAY 25

TUESDAY 26

WEDNESDAY 27

THURSDAY 28

FRIDAY 29

SATURDAY 30

Passover (Pesach), Seventh Day

Last Quarter **SUNDAY 1**

Passover (Pesach), Eighth Day

MAY

2 MONDAY

Early May Bank Holiday, UK

3 TUESDAY

4 WEDNESDAY

5 THURSDAY

Ascension Day

6 FRIDAY

7 SATURDAY

8 SUNDAY

New Moon

NATURAL FEATURES

Catbells is one of the great favourites, a family fell where grandmothers and infants can climb the heights together, a place beloved. Its popularity is well deserved: its shapely topknot attracts the eye, offering a steep but obviously simple scramble to the small summit; its slopes are smooth, sunny and sleek; its position overlooking Derwentwater is superb. Moreover, for stronger walkers it is the first step on a glorious ridge that bounds Borrowdale on the west throughout its length with Newlands down on the other side. There is beauty everywhere — and nothing but beauty. Its ascent from Keswick may conveniently, in the holiday season, be coupled with a sail on the lake, making the expedition rewarding out of all proportion to the small effort needed. Even the name has a magic challenge.

Yet this fell is not quite so innocuous as is usually thought, and grandmothers and infants should have a care as they romp around. There are some natural hazards in the form of a line of crags that starts at the summit and slants down to Newlands, and steep outcrops elsewhere. More dangerous are the levels and open shafts that pierce the fell on both flanks: the once-prosperous Yewthwaite Mine despoils a wide area in the combe above Little Town in Newlands, to the east the debris of the ill-starred Brandley Mine is lapped by the water of the lake, and the workings of the Old Brandley Mine, high on the side of the fell at Skelgill Bank, are in view on the ascent of the ridge from the north. A tragic death in one of the open Yewthwaite shafts in 1962 serves as a warning.

Words cannot adequately describe the rare charm of Catbells, nor its ravishing view. But no publicity is necessary: its mere presence in the Derwentwater scene is enough. It has a bold 'come hither' look that compels one's steps, and no suitor ever returns disappointed, but only looking back often. It has only to be seen from Friar's Crag — and a spell is cast. No Keswick holiday is consummated without a visit to Catbells.

from Yewthwaite Combe

ASCENT FROM NEWLANDS

via SKELGILL
1200 feet of ascent : 1¾ miles
from Stair

via LITTLE TOWN
950 feet of ascent : 1½ miles
from Little Town

CATBELLS

CATBELLS

Hause Gate

heather

wide grass paths

heather

heather

old levels and shafts

bracken

LITTLE TOWN

Yewthwaite Mine

yewthwaite gill grass

bracken

wide green path

The open fell is reached at Skelgill. The big zigzag was originally a miners' route — walkers have added the inevitable short cut.

Little Town is the littlest town of all — no shop, no inn, no post office, some lodging.

The steep lower flank of Maiden Moor rises on this side

Skelgill

ROAD

ROAD

STAIR 1½

Little Town

ROAD

NEWLANDS CHURCH ½

UPPER NEWLANDS

A signpost in Stair village points to Skelgill along a side-road that looks private but is public; it goes through Skelgill farmyard to Hawse End, joining the Grange road.

Leave the road by a gate just before the last cottage.

looking south-east

looking east

Up one way and down the other is a nice idea

MAY

MONDAY **9**

TUESDAY **10**

WEDNESDAY **11**

THURSDAY **12**

FRIDAY **13**

SATURDAY **14**

SUNDAY **15**

Whit Sunday (Pentecost)

MAY

16 **MONDAY**

17 **TUESDAY**

18 **WEDNESDAY**

19 **THURSDAY**

20 **FRIDAY**

21 **SATURDAY**

22 **SUNDAY**

Trinity Sunday

THE SUMMIT

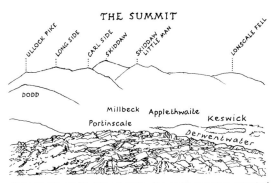

The summit, which has no cairn, is a small platform of naked rock, light brown in colour and seamed and pitted with many tiny hollows and crevices that collect and hold rainwater — so that, long after the skies have cleared, glittering diamonds adorn the crown. Almost all the native vegetation has been scoured away by the varied footgear of countless visitors; so popular is this fine viewpoint that often it is difficult to find a vacant perch. In summer this is not a place to seek quietness.
DESCENTS: Leave the top only by the ridge; lower down there is a wealth of choice. Keep clear of the craggy Newlands face.

RIDGE ROUTE

TO MAIDEN MOOR, 1887'
1½ miles : S. then SW
Depression (Hause Gate) at 1180'
720 feet of ascent

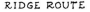

CATBELLS

Almost at once a little band of rock has to be negotiated, after which a broad path goes easily down to Hause Gate a 'cross-roads.

Hause Gate

NEWLANDS

Trap Knolls

pools

Black Crag

GRANGE

Bull Crag

N

Bull Crag

Continue across Hause Gate on an improving path, climbing steadily to a cairn on the edge of the summit, where turn right, leaving the path, above a line of cliffs to the grassy top (no cairn).

Trap Knolls

Yewthwaite Combe

Maiden Moor from Hause Gate

X MAIDEN MOOR

HALF A MILE

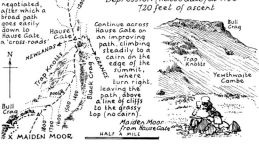

THE VIEW

Scenes of great beauty unfold on all sides, and they are scenes in depth to a degree not usual, the narrow summit permitting downward views of Borrowdale and Newlands within a few paces. Nearby valley and lake attract the eye more than the distant mountain surround, although Hindscarth and Robinson are particularly prominent at the head of Newlands and Causey Pike towers up almost grotesquely directly opposite. On this side the hamlet of Little Town is well seen down below, a charming picture, but it is to Derwentwater and mid-Borrowdale that the captivated gaze returns again and again.

Principal Fells

BINSEY
N
ULLOCK PIKE
LONG SIDE
CARL SIDE
SKIDDAW LITTLE MAN
LONSCALE FELL
MUNGRISDALE COMMON
BLENCATHRA
LORDS SEAT
BARF
GRISEDALE PIKE
BARROW
CAUSEY PIKE
SCAR CRAGS
WALLA CRAG
CLOUGH HEAD
EEL CRAG & SAIL
GREAT DODD
W ---
WANDOPE
ARD CRAGS
BLEABERRY FELL
E
WHITELESS PIKE
KNOTT RIGG
STYBARROW DODD
STARLING DODD
HIGH SEAT
RAISE
RED PIKE
ROBINSON
WHITE SIDE
CATSTYCAM
HINDSCARTH
DALE HEAD
MAIDEN MOOR
KINGS HOW
HELVELLYN
NETHERMOST PIKE
DOLLYWAGGON PIKE
(summit not seen)
ULLSCARF
FAIRFIELD
SEAT SANDAL
GLARAMARA
5 miles
HIGH RAISE
7½ miles
PIKE O' STICKLE
S

Lakes and Tarns
NNE to E: *Derwentwater*
NNW: *Bassenthwaite Lake*

MAY

Full Moon

MONDAY 23

TUESDAY 24

WEDNESDAY 25

Cartmel Races

THURSDAY 26

Corpus Christi

FRIDAY 27

SATURDAY 28

Cartmel Races

SUNDAY 29

Blencathra

2847'

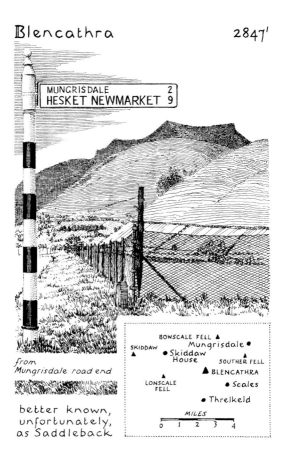

MUNGRISDALE 2
HESKET NEWMARKET 9

from
Mungrisdale road end

better known,
unfortunately,
as Saddleback

BOWSCALE FELL ▲
Mungrisdale ●
SKIDDAW ▲ ● Skiddaw
 House
 SOUTHER FELL ●
 ▲ BLENCATHRA
LONSCALE
FELL ▲ ● Scales
 ● Threlkeld

MILES
0 1 2 3 4

MAY ~ JUNE

Last Quarter

MONDAY 30

Spring Bank Holiday
Cartmel Races

TUESDAY 31

WEDNESDAY 1

THURSDAY 2

FRIDAY 3

SATURDAY 4

SUNDAY 5

JUNE

6 **MONDAY** New Moon

7 **TUESDAY**

8 **WEDNESDAY**

9 **THURSDAY**

10 **FRIDAY**

11 **SATURDAY**

Queen's Official Birthday (subject to confirmation)

12 **SUNDAY**

Brough Hound and Terrier Show (Castle Garth)

NATURAL FEATURES

Blencathra is one of the grandest objects in Lakeland. And one of the best known. Seen from the south-west, the popular aspect, the mountain rises steeply and in isolation above the broad green fields of Threlkeld, a feature being the great sweeping curve leaping out of the depths to a lofty summit-ridge, where the skyline then proceeds in a succession of waves to a sharp peak before descending, again in a graceful curve, to the valley pastures far to the east.

This is a mountain that compels attention, even from those dull people whose eyes are not habitually lifted to the hills. To artists and photographers it is an obvious subject for their craft; to sightseers passing along the road or railway at its base, between Keswick and Penrith, its influence is magnetic; to the dalesfolk it is the eternal background to their lives, there at birth, there at death. But most of all it is a mountaineers' mountain.

continued

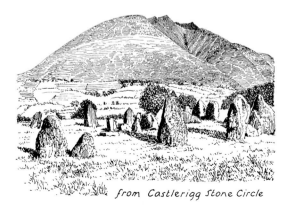

from Castlerigg Stone Circle

ASCENT FROM THRELKELD
via HALL'S FELL
2400 feet of ascent : 2 miles

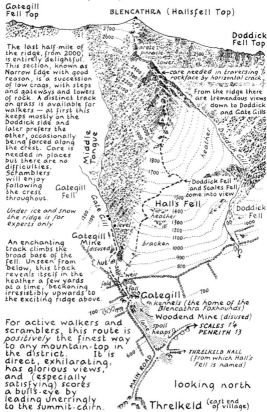

Gategill
Fell Top

BLENCATHRA (Hallsfell Top)

Doddick
Fell Top

The last half mile of
the ridge, from 2000',
is entirely delightful.
This section, known as
Narrow Edge with good
reason, is a succession
of low crags, with steps
and gateways and towers
of rock. A distinct track
on grass is available for
walkers — at first this
keeps mostly on the
Doddick side and
later prefers the
other, occasionally
being forced along
the crest. Care is
needed in places
but there are no
difficulties.
Scramblers
will enjoy
following
the crest
throughout.

care needed in traversing
rockface by horizontal crack

From the ridge there
are tremendous views
down to Doddick
and Gate Gills

Under ice and snow
the ridge is for
experts only

Gategill
Fell

Middle Tongue

Gate Gill

Hall's Fell

heather

Doddick Gill

Doddick Fell
and Scales Fell
come into view

Doddick
Fell

An enchanting
track climbs the
broad base of the
fell. Unseen from
below, this track
reveals itself in the
heather a few yards
at a time, beckoning
irresistibly upwards to
the exciting ridge above.

Gategill
Mine
(disused)

level

hut

fold

weir

fall

Gategill

kennels (the home of the
Blencathra Foxhounds)

Woodend Mine (disused)

spoil
heaps

SCALES 1/4
PENRITH 13

For active walkers and
scramblers, this route is
positively the finest way
to any mountain-top in
the district. It is
direct, exhilarating,
has glorious views,
and (especially
satisfying) scores
a bull's-eye by
leading unerringly
to the summit-cairn.

THRELKELD HALL
(from which Hall's
Fell is named)

MAIN ROAD

looking north

Threlkeld (east end
of village)

JUNE

MONDAY 13

Jewish Feast of Weeks (Shavuot)

TUESDAY 14

First Quarter

WEDNESDAY 15

THURSDAY 16

FRIDAY 17

SATURDAY 18

SUNDAY 19

Father's Day, UK

20 **MONDAY**

21 **TUESDAY**

Summer Solstice

22 **WEDNESDAY**

Full Moon

23 **THURSDAY**

24 **FRIDAY**

25 **SATURDAY**

Whitehaven Maritime Festival

26 **SUNDAY**

Whitehaven Maritime Festival

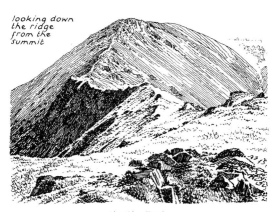

looking down
the ridge
from the
summit

Hall's Fell

the middle
section

the curve in
the ridge

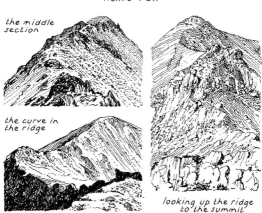

looking up the ridge
to the summit

ASCENT FROM SCALES
via SCALES FELL
2150 feet of ascent · 2¼ miles

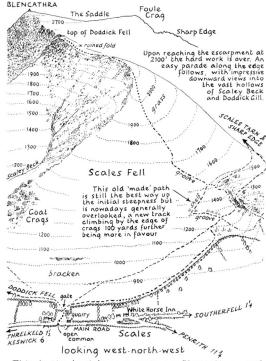

BLENCATHRA

The Saddle

Foule Crag

2700

top of Doddick Fell

Sharp Edge

× ruined fold

Upon reaching the escarpment at 2100' the hard work is over. An easy parade along the edge follows, with impressive downward views into the vast hollows of Scaley Beck and Doddick Gill.

1900
1800
1700
1600
1500

2000

grass

SCALES TARN & SHARP EDGE

1400

1900

1300

1800

1700

1200

scaley beck

1600

Scales Fell

1500

groove

1300

This old 'made' path is still the best way up the initial steepness but is nowadays generally overlooked, a new track climbing by the edge of crags 100 yards further being more in favour

shelf

1400

Goat Crags

groove

1200

1200

1100

1100

1000

900

bracken

DODDICK FELL

gate

White Horse Inn

SOUTHERFELL 1¼

quarry

MAIN ROAD

Scales

PENRITH 11¾

THRELKELD 1½
KESWICK 6

open common

looking west·north·west

This is the best-known route up Blencathra, and has been in common use for over a century. Even so, the tough grass of Scales Fell has resisted the formation of a continuous track. The climb, tedious up to 2000', becomes excellent in its later stages.

JUNE ~ JULY

MONDAY **27**

Last Quarter

TUESDAY **28**

WEDNESDAY **29**

THURSDAY **30**

FRIDAY **1**

SATURDAY **2**

SUNDAY **3**

Ullock Pike

2230'

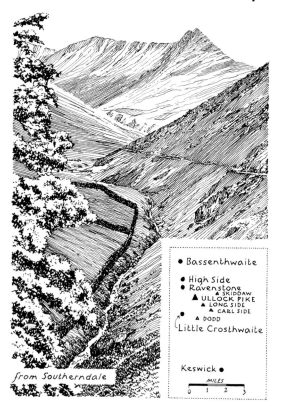

from Southerndale

● Bassenthwaite

● High Side
● Ravenstone
 ▲ SKIDDAW
▲ ULLOCK PIKE
 ▲ LONG SIDE
 ▲ CARL SIDE
● ▲ DODD
Little Crosthwaite

Keswick ●

MILES

0 1 2 3

JULY

MONDAY 4

TUESDAY 5

New Moon

WEDNESDAY 6

THURSDAY 7

FRIDAY 8

SATURDAY 9

Lakeland Rose Show (Crooklands)

SUNDAY 10

Lakeland Rose Show
Carlisle Carnival

JULY

11 **MONDAY**

12 **TUESDAY**

Holiday, Northern Ireland (Battle of the Boyne)

13 **WEDNESDAY**

14 **THURSDAY** First Quarter

Cartmel Races

15 **FRIDAY**

St Swithin's Day

16 **SATURDAY**

Cumberland County Show (Carlisle)

17 **SUNDAY**

NATURAL FEATURES

South-east of Bassenthwaite village, pleasant pastures rise to form, at the top intake wall, a wide shoulder of rough fell, and this in turn runs south and climbs as a narrowing ridge to a dark and symmetrical peak. The ridge, curved like a bow, is known as the Edge, and the dark peak is Ullock Pike. As seen on the approach from Bassenthwaite this slender pyramid is one of the simplest yet finest mountain forms in Lakeland, but its outline commands little attention from other directions, whence it is seen to be no more than a hump at the end of a greater and elevated ridge springing out of the stony bosom of Skiddaw. The western flank falls roughly to Bassenthwaite Lake, the lower slopes here being afforested, and this aspect of the fell is familiar to frequenters of the district; the less well known eastern flank, concealed from the gaze of tourists, drops even more steeply to the upland hollow of Southerndale. Streams are few, the fell drying quickly like the ridged roof of a building, which it resembles.

Watches

Astride the lower level section of the Edge, not far above the intake wall and directly overlooking the footbridge in Southerndale, is a strange and interesting congregation of upstanding rocks, huddled together as though assembled in conference, and suggesting, at first sight, a Druids' Circle. The formation is natural, however, but unusual and (being in the midst of grass) unexpected. Large-scale Ordnance maps give the equally-intriguing name of WATCHES to this place.

ASCENTS FROM BASSENTHWAITE VILLAGE AND HIGH SIDE

2000 feet of ascent : 3¼ miles (from Bassenthwaite Village)
1900 feet : 2½ miles (from High Side)

ULLOCK PIKE

LONG SIDE

Carlside col

The head of Southerndale

1900
1800
1700
1600
1500
heather

Southerndale Beck

The Edge

1100

"...... by heather tracks wi' heaven in their wilds"
The last quarter·mile

Above the intake wall the Edge may be gained easily at any point.

The top appears so clean·cut and well·defined on the ascent that, on reaching it, a second and higher top just beyond comes as a surprise.

fold

Watches

grass

1000

900

RAVENSTONE
intake wall

gate

gate

800

gates

boulder

700

Barkbeth

gorse

600

500

High Side

farm road

ruin

500

ORTHWAITE 2

BASSENTHWAITE VILLAGE 1¼
CASTLE INN 1½

RAVENSTONE
MAIN ROAD
KESWICK 6

The rising ground above the Orthwaite road leads naturally to the Edge, the long north ridge of Ullock Pike, a splendid line of approach along a narrowing and elevated stairway: a short, enjoyable climb, with superb views from the small peaked summit.

Chapel Beck

Burthwaite

Bassenthwaite Village

looking south·south·east

JULY

MONDAY 18

TUESDAY 19

WEDNESDAY 20

Full Moon **THURSDAY** 21

FRIDAY 22

SATURDAY 23

Penrith Agricultural Show (Brougham Hall Farm)

SUNDAY 24

JULY

25 **MONDAY**

26 **TUESDAY**

27 **WEDNESDAY**

28 **THURSDAY** Last Quarter

29 **FRIDAY**

30 **SATURDAY**

Cumbria Steam Gathering (Flookburgh)

31 **SUNDAY**

Cumbria Steam Gathering

THE VIEW

The praises of some Lakeland views are sung to excess, but here is one rarely mentioned yet ranking with the best. True, Skiddaw looms very large nearby but in other directions the prospect is superb, ranging from the exciting skyline across the southern horizon to the distant hills of Galloway beyond the wide coastal plain of Cumberland and the Solway Firth.

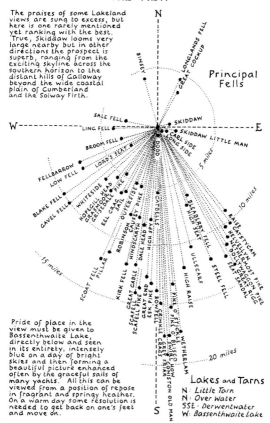

Principal Fells

Pride of place in the view must be given to Bassenthwaite Lake, directly below and seen in its entirety, intensely blue on a day of bright skies and then forming a beautiful picture enhanced often by the graceful sails of many yachts. All this can be viewed from a position of repose in fragrant and springy heather. On a warm day some resolution is needed to get back on one's feet and move on.

Lakes and Tarns

N : Little Tarn
N : Over Water
SSE : Derwentwater
W : Bassenthwaite Lake

Mellbreak

1676'

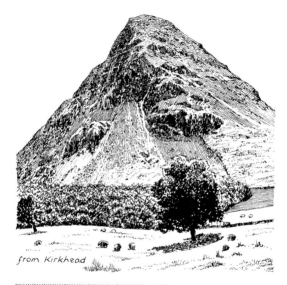

from Kirkhead

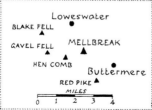

In West Cumberland, where Mellbreak is a household word (largely through long association with the Melbreak Foxhounds (spelt with one 'l')) the fell is highly esteemed, and there have always been people ready to assert that it is the finest of all. This is carrying local patriotism too far, but nevertheless it is a grand hill in a beautiful situation with a character all its own and an arresting outline not repeated in the district.

There is only one Mellbreak.

AUGUST

MONDAY 1

Summer Bank Holiday, Scotland

TUESDAY 2

WEDNESDAY 3

Cartmel Agricultural Show

THURSDAY 4

New Moon

FRIDAY 5

Lowther Horse Driving & Country Fair

SATURDAY 6

Lowther Horse Driving & Country Fair
Cockermouth Agricultural Show

SUNDAY 7

Lowther Horse Driving & Country Fair

AUGUST

8 MONDAY

9 TUESDAY

Lunesdale Agricultural Show (Underley Park)

10 WEDNESDAY

11 THURSDAY

12 FRIDAY

13 SATURDAY First Quarter

14 SUNDAY

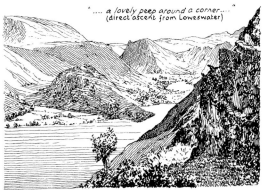

" a lovely peep around a corner...."
(direct ascent from Loweswater)

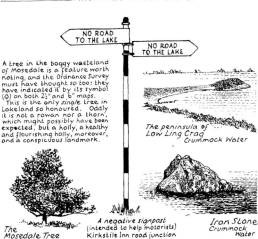

NO ROAD
TO THE LAKE

NO ROAD
TO THE LAKE

A tree in the boggy wasteland of Mosedale is a feature worth noting, and the Ordnance Survey must have thought so too: they have indicated it by its symbol (♤) on both 2½" and 6" maps.
This is the only *single* tree in Lakeland so honoured. Oddly it is not a rowan nor a thorn, which might possibly have been expected, but a holly, a healthy and flourishing holly, moreover, and a conspicuous landmark.

The peninsula of
Low Ling Crag
Crummock Water

The
Mosedale Tree

A negative signpost
(intended to help motorists)
Kirkstile Inn road junction

Iron Stone
Crummock
Water

ASCENT (to the north top) FROM LOWESWATER
1300 feet of ascent : 1¼ miles

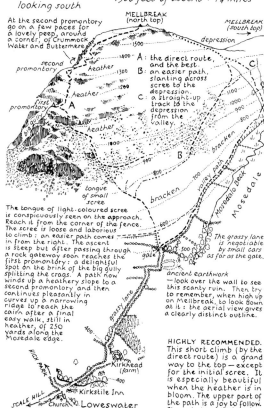

looking south

At the second promontory go on a few paces for a lovely peep, around a corner, of Crummock Water and Buttermere.

second promontory

first promontory

MELLBREAK (north top)

MELLBREAK (south top)

depression

A: the direct route and the best.
B: an easier path, slanting across scree to the depression.
C: a straight-up track to the depression from the valley.

heather

heather

heather

big gully

tongue of small scree

bracken

bracken

valley path

Moseedale beck

Mosedale

The tongue of light-coloured scree is conspicuously seen on the approach. Reach it from the corner of the fence. The scree is loose and laborious to climb: an easier path comes in from the right. The ascent is steep but after passing through a rock gateway soon reaches the first promontory: a delightful spot on the brink of the big gully splitting the crags. A path now winds up a heathery slope to a second promontory and then continues pleasantly in curves up a narrowing ridge to reach the cairn after a final easy walk, still in heather, of 250 yards along the Mosedale edge.

The grassy lane is negotiable by small cars as far as the gate.

gate

ancient earthwork — look over the wall to see this scanty ruin. Then try to remember, when high up on Mellbreak, to look down at it: the aerial view gives a clearly distinct outline.

grassy lane

HIGH PARK

SCALE HILL

Church

Kirkhead (farm)

Kirkstile Inn
Loweswater

HIGHLY RECOMMENDED. This short climb (by the direct route) is a grand way to the top — except for the initial scree. It is especially beautiful when the heather is in bloom. The upper part of the path is a joy to follow. Steep, but no difficulties.

AUGUST

MONDAY 15

TUESDAY 16

WEDNESDAY 17

Gosforth Agricultural Show

THURSDAY 18

Full Moon

FRIDAY 19

SATURDAY 20

SUNDAY 21

AUGUST

22 **MONDAY**

23 **TUESDAY**

24 **WEDNESDAY**

25 **THURSDAY**

26 **FRIDAY** Last Quarter

27 **SATURDAY**

 Cartmel Races

28 **SUNDAY**

 Grasmere Sports & Show

ASCENT FROM CRUMMOCK WATER
1350 feet of ascent : ¾ mile (to the north top)
1450 feet of ascent : 1 mile
(to the south top)

MELLBREAK
south top

MELLBREAK
north top

1600

1500

1600

1500

1400

1300

1200

The only merit in
this steep line of
ascent is the
remarkable rock
scenery of the short
section of the route
below the upper crag.
A rising grass rake
at the base of the
crag provides a
narrow passage
and from this
gangway four
rocky pillars
form a broken
parapet and
fall as aretes
towards the
lake. Apart
from this,
the route
has little to
commend it.

Pillar Rake

Do NOT attempt a
slanting route to the
Rake from Green Wood.
Knee-deep heather and
steepness make this a
bad crossing.
Go up
the open screeslope
further along.

1000

900

800

700

600

500

heather

Green
Wood

grass

bracken

400

Crummock Water

hurdle

stile

SCALEHILL BRIDGE

Pillar Rake,
lower section,
from the north.
(route indicated)

looking
southwest

Pillar Rake, looking back
at the first two pillars
(route indicated)

SCREE
SLOPE

Hart Side

2481'

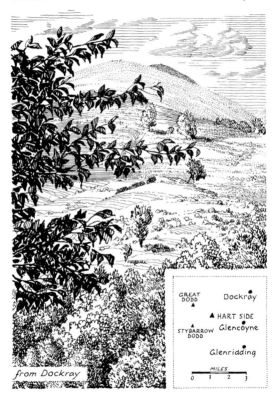

from Dockray

GREAT
DODD ▲

STYBARROW
DODD ▲

▲ HART SIDE

● Dockray

● Glencoyne

● Glenridding

MILES
0 1 2 3

AUGUST ~ SEPTEMBER

MONDAY **29**

Summer Bank Holiday, UK (exc. Scotland)
Cartmel Races
Keswick Agricultural Show

TUESDAY **30**

WEDNESDAY **31**

THURSDAY **1**

CAMRA Charter Beer Festival (Ulverston)

FRIDAY **2**

CAMRA Charter Beer Festival

New Moon

SATURDAY **3**

CAMRA Charter Beer Festival

SUNDAY **4**

SEPTEMBER

5 MONDAY

6 TUESDAY

7 WEDNESDAY

8 THURSDAY

Westmorland County Show

9 FRIDAY

Kendal Torchlight Procession

10 SATURDAY

11 SUNDAY First Quarter

NATURAL FEATURES

The main watershed at Stybarrow Dodd sends out a long spur to the east which curves north from the subsidiary height of Green Side and continues at an elevated level until it is poised high above Ullswater before descending in wide slopes to the open country around Dockray. The principal height on this spur is Hart Side, which with its many satellites on the declining ridge forms the southern wall of the long valley of Deep Dale throughout its sinuous course, its opposite boundary being the short deep trench of Glencoyne. The upper slopes of this bulky mass are unattractive in themselves, but, in strong contrast, the steep flank overlooking Ullswater is beautifully wooded, while the views of the lake from the Brown Hills, midway along the ridge, are of high quality.

Hart Side is rarely visited. Its smooth slopes, grass and marsh intermingling, seem very very remote from industry, but there are evidences that men laboured on these lonely heights a long time ago, and even now the minerals far below its surface are being won by the enterprising miners of Glenridding.

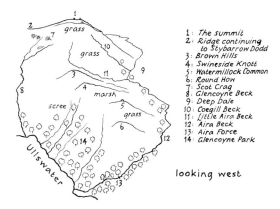

1 : The summit
2 : Ridge continuing to Stybarrow Dodd
3 : Brown Hills
4 : Swineside Knott
5 : Watermillock Common
6 : Round How
7 : Scot Crag
8 : Glencoyne Beck
9 : Deep Dale
10 : Coegill Beck
11 : Little Aira Beck
12 : Aira Beck
13 : Aira Force
14 : Glencoyne Park

looking west

ASCENT FROM DOCKRAY
1600 feet of ascent : 4 miles

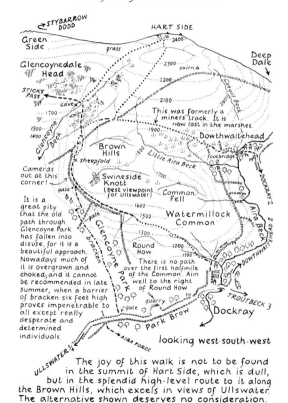

→ STYBARROW DODD

HART SIDE

Green Side

2400

Glencoynedale Head

2300

Deep Dale

2200

cairn △

STICKS PASS

grass

2100

cave ×

This was formerly a miners' track. It is now lost in the marshes.

1700

Dowthwaitehead

1500

1400

1900

footbridge

Glencoyne Beck

Brown Hills

Little Aira Beck

1800

DOCKRAY 2

sheepfold

Aira Beck

Cameras out at this corner!

Swineside Knott (best viewpoint for Ullswater)

1700

Common Fell

Aira Beck 2

gate

1600

It is a great pity that the old path through Glencoyne Park has fallen into disuse, for it is a beautiful approach. Nowadays much of it is overgrown and choked; and it cannot be recommended in late summer, when a barrier of bracken six feet high proves impenetrable to all except really desperate and determined individuals.

gate

1500

Watermillock Common

1300

Round How

1200

There is no path over the first half-mile of the Common. Aim well to the right of Round How.

1100

DOWTHWAITE

gate

Glencoyne Park

bracken

quarry

Park Brow

Dockray

TROUTBECK 3

gate

ULLSWATER!

AIRA FORCE

looking west·south·west

The joy of this walk is not to be found in the summit of Hart Side, which is dull, but in the splendid high-level route to it along the Brown Hills, which excels in views of Ullswater. The alternative shown deserves no consideration.

SEPTEMBER

MONDAY 12

TUESDAY 13

WEDNESDAY 14

THURSDAY 15

FRIDAY 16

SATURDAY 17

Full Moon

SUNDAY 18

SEPTEMBER

19 MONDAY

20 TUESDAY

21 WEDNESDAY

22 THURSDAY

Autumnal Equinox

23 FRIDAY

24 SATURDAY

25 SUNDAY Last Quarter

THE SUMMIT

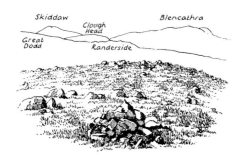

Skiddaw — Clough Head — Blencathra
Great Dodd — Randerside

The summit has nothing extraordinary to show in natural forms, being grassy with a few outcropping boulders. Yet this is a top that cannot be confused with any other, for here man has not contented himself merely with building a few cairns but has really got to work with pick and spade, and excavated a most remarkable ditch, rather like the Vallum of the Roman Wall. As the project was abandoned, the reason for the prodigious effort is not clear. An excavation below the summit, intended as the site of a building, was similarly abandoned. Probably these were workings for the Glenridding lead mine, as is a cave in Glencoynedale Head, near the miners' path: here a warning notice—"Danger. Keep Out."— relieves the duly grateful guide-book writer of the task of exploring its fearsome interior.

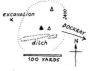

excavation × ... 2400 ... DOCKRAY ... ditch ... 100 YARDS ... N

The ditch on the summit

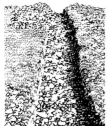

The cave

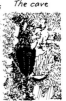

DESCENTS: Descents will usually be either to Dockray or Glencoyne Walk ESE, over a minor rise, to the wall running across the fell. Follow the wall down, joining the miners' path (at a gap) for Dockray. For Glencoyne, continue by the wall down into the valley. These are the best routes in mist.

26 MONDAY

27 TUESDAY

28 WEDNESDAY

29 THURSDAY

Michaelmas Day

30 FRIDAY

1 SATURDAY

2 SUNDAY

THE VIEW

Principal Fells

The view is disappointing. Although Hart Side has a considerable altitude, it does not overtop the main ridge to the west, which hides all the high fells beyond. Intervening ground to the east conceals most of Ullswater.

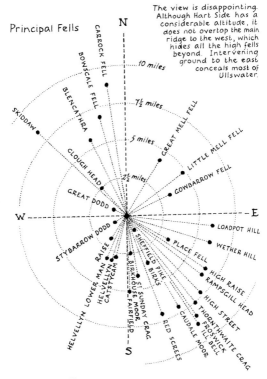

Lakes and Tarns
ENE : Ullswater

Scafell Pike

3210'

the highest mountain in England

formerly 'The Pikes' or 'The Pikes of Scawfell';
'Scafell Pikes' on Ordnance Survey maps.

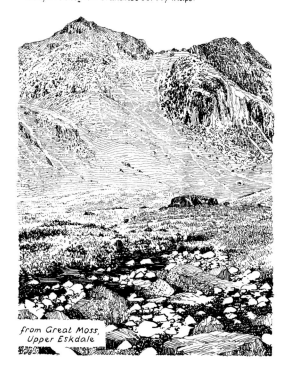

from Great Moss,
Upper Eskdale

OCTOBER

New Moon MONDAY 3

TUESDAY 4

Jewish New Year (Rosh Hashanah)
First Day of Ramadân (subject to sighting of the moon)

WEDNESDAY 5

THURSDAY 6

FRIDAY 7

SATURDAY 8

SUNDAY 9

OCTOBER

10 MONDAY First Quarter

11 TUESDAY

12 WEDNESDAY

13 THURSDAY

Jewish Day of Atonement (Yom Kippur)

14 FRIDAY

15 SATURDAY

16 SUNDAY

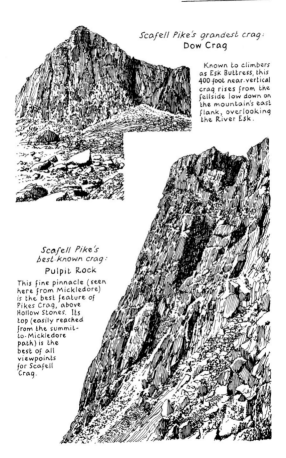

Scafell Pike's grandest crag:
Dow Crag

Known to climbers as Esk Buttress, this 400-foot near-vertical crag rises from the fellside low down on the mountain's east flank, overlooking the River Esk.

Scafell Pike's best-known crag:
Pulpit Rock

This fine pinnacle (seen here from Mickledore) is the best feature of Pikes Crag, above Hollow Stones. Its top (easily reached from the summit-to-Mickledore path) is the best of all viewpoints for Scafell Crag.

ASCENT FROM WASDALE HEAD
via BROWN TONGUE

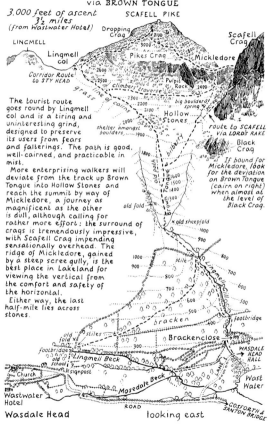

3,000 feet of ascent
3½ miles
(from Wastwater Hotel)

SCAFELL PIKE

LINGMELL

Lingmell col

Scafell Crag

Corridor Route to STY HEAD

Dropping Crag

3100

3000

Pikes Crag

Mickledore

2600

2500

Climbers' traverse

Pulpit Rock

2400

line of cairns

2300

2200

2100

big boulders

Hollow Stones

3000

shelter amongst boulders

1900

route to SCAFELL via LORD'S RAKE

Black Crag

The tourist route goes round by Lingmell col and is a tiring and uninteresting grind, designed to preserve its users from fears and falterings. The path is good, well-cairned, and practicable in mist.

More enterprising walkers will deviate from the track up Brown Tongue into Hollow Stones and reach the summit by way of Mickledore, a journey as magnificent as the other is dull, although calling for rather more effort: the surround of crags is tremendously impressive, with Scafell Crag impending sensationally overhead. The ridge of Mickledore, gained by a steep scree gully, is the best place in Lakeland for viewing the vertical from the comfort and safety of the horizontal.

Either way, the last half-mile lies across stones.

If bound for Mickledore, look for the deviation on Brown Tongue (cairn on right) when almost at the level of Black Crag.

old path

1800

1700

bilberry

1600

1500

1400

1300

old fold

old sheepfold

1000

900

800

stile

1000

900

700

600

500

Lingmell Gill

bracken

700

600

500

footbridge

old fold

stiles

footbridge

Lingmell Beck

Brackenclose

WASDALE HEAD HALL

school

signpost

Church

Mosedale Beck

West Water

Wastwater Hotel

ROAD

COSFORTH & SANTON BRIDGE

Wasdale Head

looking east

OCTOBER

Full Moon

MONDAY **17**

TUESDAY **18**

Jewish Festival of Tabernacles (Succoth), First Day

WEDNESDAY **19**

THURSDAY **20**

FRIDAY **21**

SATURDAY **22**

SUNDAY **23**

OCTOBER

24 **MONDAY**

25 **TUESDAY** Last Quarter

Jewish Festival of Tabernacles (Succoth), Eighth Da

26 **WEDNESDAY**

27 **THURSDAY**

28 **FRIDAY**

29 **SATURDAY**

30 **SUNDAY**

British Summertime ends

THE VIEW

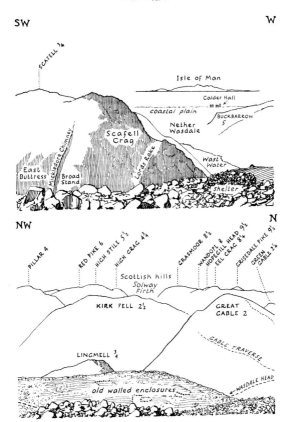

SW W

SCAFELL 3¼

Isle of Man

Calder Hall

coastal plain

BUCKBARROW 5

Nether Wasdale

Scafell Crag

Lord's Rake

Wast Water

East Buttress

Micklodore Chimney

Broad Stand

shelter

NW N

PILLAR 4

RED PIKE 6

HIGH STILE 5½

HIGH CRAG 4¾

CRASMOOR 8½

WANDOPE 8
HOPEGILL HEAD 9½
EEL CRAG 8½

CRISEDALE PIKE 9½

GREEN GABLE 2¼

Scottish hills
Solway Firth

KIRK FELL 2½

GREAT GABLE 2

GABLE TRAVERSE

LINGMELL ¾

WASDALE HEAD

old walled enclosures

Great Gable

2949'

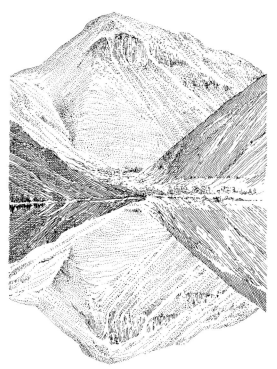

from Wastwater

MONDAY 31

Hallowe'en

TUESDAY 1

All Saints' Day

New Moon

WEDNESDAY 2

THURSDAY 3

FRIDAY 4

SATURDAY 5

Guy Fawkes' Day

SUNDAY 6

NOVEMBER

7 **MONDAY**

8 **TUESDAY**

9 **WEDNESDAY** First Quarter

10 **THURSDAY**

11 **FRIDAY**

12 **SATURDAY**

13 **SUNDAY**

Remembrance Sunday, UK

NATURAL FEATURES

Great Gable is a favourite of all fellwalkers, and first favourite with many. Right from the start of one's apprenticeship in the hills, the name appeals magically. It is a good name for a mountain, strong, challenging, compelling, starkly descriptive, suggesting the pyramid associated with the shape of mountains since early childhood. People are attracted to it because of the name. There is satisfaction in having achieved the ascent and satisfaction in announcing the fact to others. The name has status, and confers status... Yes, the name is good, simple yet subtly clever. If Great Gable were known only as Wasdale Fell fewer persons would climb it.

continued

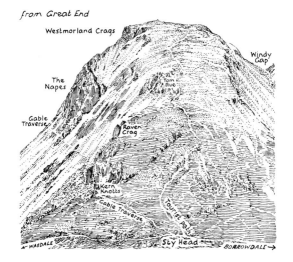

from Great End

Westmorland Crags

Windy Gap

The Napes

Tom in Blue

Gable Traverse

Raven Crag

Kern Knotts

Gable Traverse

Tourist Path

← WASDALE

Sty Head

BORROWDALE →

ASCENT FROM SEATHWAITE
2700 feet of ascent
2¾ miles

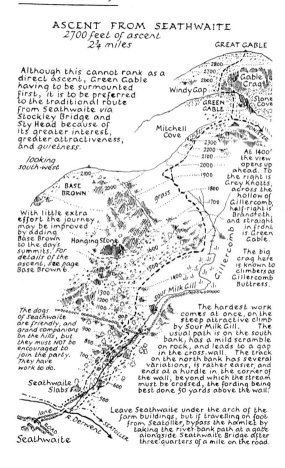

GREAT GABLE

Although this cannot rank as a direct ascent, Green Gable having to be surmounted first, it is to be preferred to the traditional route from Seathwaite via Stockley Bridge and Sly Head because of its greater interest, greater attractiveness, and quietness.

looking south-west

BASE BROWN

With little extra effort the journey may be improved by adding Base Brown to the day's summits. For details of the ascent, see page Base Brown 6.

Hanging Stone

Windy Gap

GREEN GABLE

Gable Crag

Stone Cove

Mitchell Cove

At 1400' the view opens up ahead. To the right is Grey Knotts, across the hollow of Gillercomb, half-right is Brandreth, and straight in front is Green Gable.

The big crag here is known to climbers as Gillercomb Buttress.

grass

Gillercomb

Sour Milk Gill

The dogs of Seathwaite are friendly, and grand companions on the hills, but they must NOT be encouraged to join the party. They have work to do.

Seathwaite Slabs

The hardest work comes at once, on the steep attractive climb by Sour Milk Gill. The usual path is on the south bank, has a mild scramble on rock, and leads to a gap in the cross-wall. The track on the north bank has several variations, is rather easier, and ends at a hurdle in the corner of the wall, beyond which the stream must be crossed, the fording being best done 50 yards above the wall.

lane
R. Derwent
SEATOLLER

Seathwaite

Leave Seathwaite under the arch of the farm buildings, but if travelling on foot from Seatoller, bypass the hamlet by taking the river-bank path at a gate alongside Seathwaite Bridge after three-quarters of a mile on the road.

NOVEMBER

MONDAY **14**

TUESDAY **15**

Full Moon WEDNESDAY **16**

THURSDAY **17**

FRIDAY **18**

SATURDAY **19**

SUNDAY **20**

NOVEMBER

21 MONDAY

22 TUESDAY

23 WEDNESDAY Last Quarter

24 THURSDAY

25 FRIDAY

26 SATURDAY

27 SUNDAY

Advent Sunday

THE VIEW

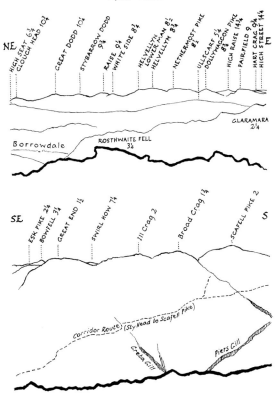

NE

HIGH SEAT 6¾
CLOUGH HEAD 10¾
GREAT DODD 10¼
STYBARROW DODD 9¼
RAISE 9¼
WHITE SIDE 8¾
HELVELLYN 8½
LOWER MAN 8½
HELVELLYN 8¾
NETHERMOST PIKE 8½
ULLSCARF 5¼
DOLLYWAGGON PIKE 8¼
HIGH RAISE 14¾
FAIRFIELD 9¾
HART CRAG 9¾
HIGH STREET 14¼

E

GLARAMARA 2¼

Borrowdale

ROSTHWAITE FELL 3¼

SE

ESK PIKE 2¼
BOWFELL 3¼
GREAT END 1½
SWIRL HOW 7¼
ILL CRAG 2
BROAD CRAG 1¾
SCAFELL PIKE 2

S

Corridor Route; (Sty Head to Scafell Pike)

Greta Gill

Piers Gill

The figures accompanying the names of fells indicate distances in miles

28 MONDAY

29 TUESDAY

30 WEDNESDAY

St Andrew's Day

1 THURSDAY

New Moon

2 FRIDAY

3 SATURDAY

4 SUNDAY

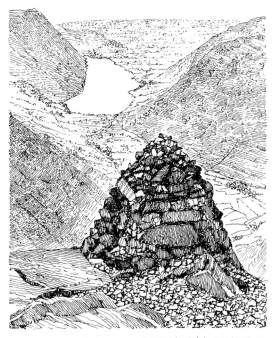

Westmorland Cairn

Erected in 1876 by two brothers of the name of Westmorland to mark what they considered to be the finest mountain viewpoint in the district, this soundly-built and tidy cairn is wellknown to climbers and walkers alike, and has always been respected. The cairn has maintained its original form throughout the years quite remarkably: apart from visitors who like to add a pebble, it has suffered neither from the weather nor from human despoilers. It stands on the extreme brink of the south face, above steep crags, and overlooks Wasdale. Rocky platforms around make the place ideal for a halt after climbing Great Gable. The cairn is not in sight from the summit but is soon reached by walking 150 yards across the stony top in the direction of Wastwater.

Caudale Moor

2502'

often referred to as
John Bell's Banner
summit named
Stony Cove Pike

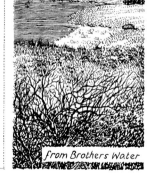

• Patterdale

• Hartsop

HIGH
STREET ▲
CAUDALE ▲ MOOR

▲ RED SCREES

• Ambleside

MILES
0 1 2 3 4

from Brothers Water

DECEMBER

MONDAY 5

TUESDAY 6

WEDNESDAY 7

First Quarter **THURSDAY 8**

FRIDAY 9

SATURDAY 10

SUNDAY 11

DECEMBER

12 MONDAY

13 TUESDAY

14 WEDNESDAY

15 THURSDAY Full Moon

16 FRIDAY

17 SATURDAY

18 SUNDAY

NATURAL FEATURES

Caudale Moor deserves far more respect than it usually gets. The long featureless slope flanking the Kirkstone Pass, well known to travellers, is not at all characteristic of the fell: its other aspects, less frequently seen, are considerably more imposing. There are, in fact, no fewer than six ridges leaving the summit in other directions, four of them of distinct merit and two of these rising to subsidiary summits, Wansfell and Hartsop Dodd, on their way to valley-level. The craggy slopes bordering the upper Troutbeck valley are particularly varied and interesting: from this remote dalehead Caudale Moor looks really impressive, especially in snowy conditions. The best single feature, however, is the formidable wall of rock, Raven Crag, overlooking Pasture Beck. Of the streams draining the fell, those to the south join forces to form Trout Beck; all others go north to feed Ullswater.

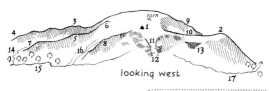

looking west

1 : The summit (Stony Cove Pike)
2 : Hartsop Dodd
3 : St. Ravens Edge
4 : Main south ridge
continuing to Wansfell
5 : Hart Crag
6 : Pike How
7 : Intermediate south ridge
8 : South ridge (east)
9 : North-west ridge
10 : North ridge
11 : East ridge
12 : Threshthwaite Mouth
13 : Raven Crag
14 : Woundale Beck
15 : Trout Beck
16 : Sad Gill
17 : Pasture Beck

The six ridges of Caudale Moor

1 : North-west (to Brothers Water)
2 : North (to Hartsop)
3 : East (to Thornthwaite Crag or Hartsop or Troutbeck)
4 : South (east) (to Troutbeck)
5 : South (intermediate) (to Troutbeck)
6 : South (west) (to Kirkstone)

ASCENT FROM TROUTBECK
2200 (A) or 2350 (B) feet of ascent;
(A) 5 miles via Sad Gill; 5½ miles via Woundale (A)
(B) 6 miles via St Ravens Edge or Threshthwaite Mouth (B)

looking north

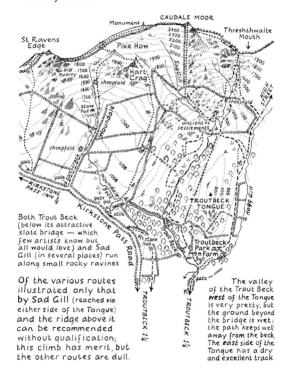

Both Trout Beck
(below its attractive
slate bridge — which
few artists know but
all would love) and Sad
Gill (in several places) run
along small rocky ravines

Of the various routes
illustrated, only that
by Sad Gill (reached via
either side of the Tongue)
and the ridge above it
can be recommended
without qualification;
this climb has merit, but
the other routes are dull.

The valley
of the Trout Beck
west of the Tongue
is very pretty, but
the ground beyond
the bridge is wet:
the path keeps well
away from the beck
The *east* side of the
Tongue has a dry
and excellent track

DECEMBER

MONDAY **19**

TUESDAY **20**

WEDNESDAY **21**

Winter Solstice

THURSDAY **22**

Last Quarter

FRIDAY **23**

SATURDAY **24**

Christmas Eve

SUNDAY **25**

Christmas Day

DECEMBER ~ JANUARY

26 MONDAY

Boxing Day (St Stephen's Day)
Jewish Festival of Chanukah, First Day
Holiday, UK

27 TUESDAY

Holiday, UK

28 WEDNESDAY

29 THURSDAY

30 FRIDAY

31 SATURDAY

New Moon

New Year's Eve

1 SUNDAY

New Year's Day

THE SUMMIT

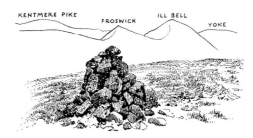

KENTMERE PIKE FROSWICK ILL BELL YOKE

The summit is a dreary plateau of considerable extent, crossed by stone walls, with grey rock outcropping in the wide expanse of grass. The highest point is not easy to locate on the flat top: it is indicated by a cairn, *east* of the north-south wall, and bears the distinctive name of Stony Cove Pike.

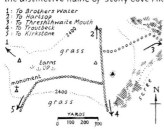

1: To Brothers Water
2: To Hartsop
3: To Threshthwaite Mouth
4: To Troutbeck
5: To Kirkstone

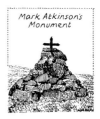

Mark Atkinson's Monument

DESCENTS: All routes of ascent may be reversed in good weather. There are no paths on the top, but (excepting the north-west ridge) accompanying walls are safe guides from the summit.

In bad weather, note that the east face is everywhere craggy: it may be descended safely *only* by the broken wall going down to the Threshthwaite gap. The best way off the top in an emergency, whatever the destination, is alongside the wall running west — this continues without a break to the road near Kirkstone Pass Inn.

Cairn above the north-west ridge